# CHRISTIE'S
## COLLECTIBLES

# CHRISTIE'S
## COLLECTIBLES

# ART NOUVEAU JEWELRY

*David Lancaster*

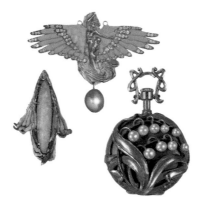

A BULFINCH PRESS BOOK
LITTLE, BROWN AND COMPANY
BOSTON • NEW YORK • TORONTO • LONDON

First North American Edition

ISBN 0-8212-2270-8

Library of Congress Catalog Card Number 95-80526

**EDITOR** GWEN RIGBY
**DESIGNER** HELEN SPENCER
**PICTURE EDITOR** ELIZABETH LOVING

Marshall Editions would like to thank
Edward Schneider of Christie's Images for his help
in the creation of this book.

Conceived, edited, and designed by
Marshall Editions
170 Piccadilly  London W1V 9DD

Bulfinch Press is an imprint and trademark of
Little, Brown and Company (Inc.)

Published simultaneously in Canada by
Little, Brown & Company (Canada) Limited

PRINTED IN PORTUGAL

CHRISTIE'S
502 Park Avenue  New York  NY 10022

CHRISTIE'S EAST
219 East 67th Street  New York  NY 10021

CHRISTIE'S CANADA
170 Bloor Street West  Suite 210  Toronto  Ontario M5S IT9

CHRISTIE'S
8 King Street  St. James's  London SW1Y 6QT

CHRISTIE'S SOUTH KENSINGTON
85 Old Brompton Road  London SW7 3LD

CHRISTIE'S AUSTRALIA
298 New South Head Road  Double Bay  Sydney  NSW 2028

CHRISTIE'S SOUTH AFRICA
P.O. Box 72126  Parkview  Johannesburg 2122

CHRISTIE'S JAPAN
Sankyo Ginza Building 6-5-13  Ginza  Chuo-ku  Tokyo 104

# Contents

### PRICE CODES
The following price codes are used in this book:
**$A** $150–$750 **$B** $751–$1,500
**$C** $1,501–$3,000 **$D** $3,001–$7,500 **$E** $7,501–$15,000
**$F** $15,001–$30,000 **$G** More than $30,000

Valuation is an imprecise art and prices can vary for many
reasons, including the condition of a piece, fashion, and national and
regional interest. Prices given in this book are approximate
and based on likely *auction* values. *Insurance* values reflect the
retail replacement price and as such are liable to be higher.

# Introduction

$\mathcal{L}$'Art Nouveau, the style that gripped France in the mid-1880s, then spread through Europe and to America, was only one of several artistic movements to flourish and fade prior to World War I. Many had their roots in the technological developments of the 19th century: the introduction and growth of railroads, the production of iron ships, cheaper newspapers, and photography. These innovations, together with the increase in consumerism, allowed changes in fashion to be transmitted quickly, and introduced a period when styles overlapped and cross-pollinated to a confusing degree.

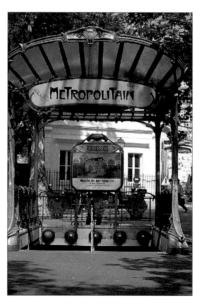

*Some of the most abiding examples of Art Nouveau style are the entrances to the Paris Metro designed by Hector Guimard.*

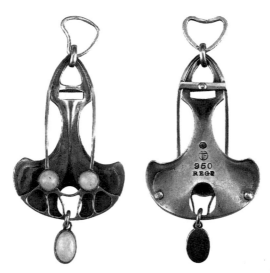

*These earrings display many of the elements of Art Nouveau
jewelry design: sinuous line,* guilloché *enamel, and opals.*

℀ catalyst for the explosion of individual art and design
was undoubtedly The Great Exhibition of the Industries
of All Nations 1851 in London – a title notably lacking
any reference to art – where the failure of manufacturers
to discriminate between artistic design and excessive
extraneous ornament was forcibly revealed. One major
exception was Augustus Pugin's medieval court, full of
pure Gothic design, which was strongly criticized for
slavishly copying the style of an earlier period. Pugin
was by no means the only craftsman to reach into
history for inspiration. The Greek, Etruscan, and
Assyrian archaeological discoveries, ancient Egypt, the
Renaissance, and the works of Holbein were all utilized
in the 1860s, by the Castellanis and Robert Phillips
among others, to create jewelry in the prevailing taste of
the time. Medieval influence was also at work in art,
with the followers of the Pre-Raphaelite movement in

Britain practicing a return to purity and realism, which was reflected in their jewelry designs, many of which were symbolic.

*A*lthough the Pre-Raphaelite Brotherhood was shortlived, dissolving in 1853, its influence remained, in 1861 bringing together the group of designers who formed Morris, Marshall, Faulkner & Co. This group was dedicated to creating fine works of art in painting, carving, furniture, and metal in contrast to the prevailing machine-made products.

*N*ot only were industrial products considered to debase art, but the working conditions were felt to debase life also. It was not enough, therefore, to encourage handicrafts; it was necessary to create the correct working conditions. In 1871 John Ruskin, the eminent art critic, set up the first cooperative, known as the Guild of St. George; eleven years later, in 1882, the Century Guild was formed. Further guilds led to the Arts and Crafts Exhibition Society, which displayed jewelry from C.R. Ashbee's English Guild of Handicraft based in London and the Birmingham Guild of Handicraft.

*An Oriental influence is strong in Charles Rennie Mackintosh's 1904 design for a chair for the Willow Tea Room, Glasgow.*

*The flowing lines and emphasis on the female form in Alphonse Mucha's work typify Art Nouveau style.*

Associated with the guilds were the schools of art. These included the innovative Glasgow School, whose leading students, among them the architect Charles Rennie Mackintosh, influenced 20th-century design, in particular through contact with Josef Hoffmann and the Wiener Werkstätte.

During the 1880s, Samuel Bing in Paris and Arthur Lasenby Liberty in London both ran galleries specializing in Oriental decorative arts, and were excited by the marketing potential of the new Art Nouveau style. Bing moved first, reopening his gallery under the title L'Art Nouveau on December 26, 1895, with an exhibition of international designs that displayed innovation but lacked cohesion. Liberty, meanwhile, had launched a line of jewelry inspired by the designs of Archibald Knox, from the School of Art in Douglas, Isle of Man. In the U.S.A., the new style was being promoted by Tiffany's. And bubbling beneath this outpouring of

creative design was the genius of René Lalique, whose daring jewels shown at the Paris salon exhibitions of 1895, '96, and '97 established his reputation.

 $\mathcal{S}$ imilar developments were taking place throughout Europe. The German *Jugendstil* designs combined Japanese and Celtic influences around naturalistic motifs, while at Darmstadt Theodor Fahrner produced work influenced by the Vienna Secession. In Britain, the drive to reject all machine work led beyond Art Nouveau to the Arts and Crafts Movement, an impractical approach to the commercial manufacture of jewelry. Along with dreams of diaphanous beauty and peace, these ideals were all swept away by the brutality of the 1914–18 war, to be replaced by machine-inspired modernist lines leading to Art Deco.

*The Secessionist style spread throughout the German-speaking world, as this Swiss advertisement shows.*

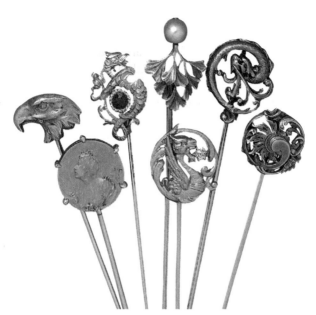

*Naturalistic, fantastic, and medallic aspects of Art Nouveau style are evident in these tie pins.*

## TIPS FOR COLLECTORS

• Buy only what you like, but remember the jewelry is between 80 and 100 years old and be wary.

• Look for later reworking, redundant suspension loops, modern safety catches, messy solder, and out-of-character areas, usually more easily seen from the back.

• Enamel, being glass, is easily damaged. Check for: chipped areas and those later stripped of enamel; repainting, especially with modern soft epoxy enamels which yield to a fingernail; open areas that once contained *plique-à-jour* enamel.

• Provenance is important. Maker's signatures or signed, fully fitted cases add to the value, but do not ignore the appeal of a photograph showing a great aunt wearing the piece or the remains of an original invoice.

# Line of leaves designs

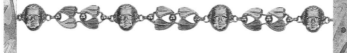

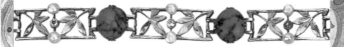

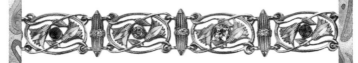

*Numerous influences are revealed by these three adaptations of a basic line of leaves theme. The gold necklace at the top, by the London jeweler Alfred Phillips, dates from c.1885, a time when the great interest in current archaeological discoveries was often reflected in the arts. It uses a form drawn from Greek examples of 475–330 B.C., joined by cupid's heads, to create a romantic jewel.*

Length 16½in/42cm   $D

*In the bracelet in the center (c.1900), the Frenchman Georges Fouquet uses a more natural leaf, joined by turquoise cabochons that have been selected for the streaks of black matrix they contain. These are enhanced by pearls, and a small diamond in each link acts as a highlight.*

Length 7¼in/18.5cm   $E

*The lower bracelet turns to Egypt for inspiration, with panels of lotus flowers entwined around diamonds, rubies, and emeralds, which are joined by ribbed husks set with diamonds. It was made by Alphonse Fouquet c.1890.*

Length c.7½in/19cm   $E

# Marcus & Co. pendant

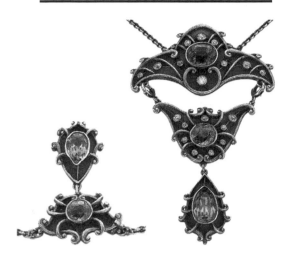

*T*HE ART OF PLIQUE-À-JOUR ENAMELING –
*filling spaces in the design with colored enamel –*
*was brought to perfection by French jewelers, notably*
*René Lalique and Eugène Feuillatre. Only a few*
*American jewel houses attempted this type of work –*
*Riker Bros. in Newark, Tiffany & Co. in New York,*
*and Marcus & Co., also of New York.*
*M*ARCUS & CO. SPECIALIZED IN EXPENSIVE, FASHIONABLE
*versions of American Arts and Crafts jewels*
*and Tiffany studio designs. This pendant necklace*
*with a matching clasp was made c.1900, using green*
*peridot gems surrounded by green* plique-à-jour
*enamel and enhanced by diamonds. The gems*
*were set in gold, with a stipple finish peculiar to this*
*maker. The two lower drops are detachable*
*and can be worn as a separate necklet. The pendant*
*is signed on the reverse and has its original case,*
*both of which are desirable features.*

Length pendant 6¾in/17cm  $E

# Lalique pendant

*BETWEEN 1897 AND 1908, René Lalique was the acknowledged master of Art Nouveau jewelry. He created flamboyant and eccentric pieces in unusual colors and materials, combining art and sculpture to depict the forms of nature. The famous exhibition pieces are well documented, but Lalique also produced an extensive range of very wearable jewelry incorporating sinuous designs within a symmetrical frame.*

*THIS FINE GOLD AND ENAMEL pendant, dating from c.1905, depicts opposed griffins, tendrils, and flower heads enameled in shaded green and blue against a dark plique-à-jour enamel ground. This difficult process created a stained-glass window effect, seen to greatest advantage when the light was able to shine through it. A loop at the base of the jewel would have supported a pearl drop, selected for its interesting shape to complement the flowing form of the natural elements of the design.*

*MANY FINE PIECES BY LALIQUE WERE BROKEN UP AND remodeled during the 1920s and '30s, when his designs were out of favor.*

Length 2¾in/7cm  $E

# Whiplash pendant

COMPARISON OF THIS
pendant with the one opposite
demonstrates the individuality
of René Lalique's design,
in which the floral
motif breaks free
of the frame
and intricate
detail abounds.
THIS JEWEL COMBINES
the whiplash lines popular
in Art Nouveau jewelry
with enameled leaves to
present an immediately
recognizable fashion
statement. On the lower
segment, plique-à-jour
enamel has been
used, but the process
was simplified by keeping
the areas of enamel small and
geometric. Cabochon rubies
give fire and life to the
piece, and the oddly
shaped natural baroque
pearl drops – almost mandatory in Art
Nouveau jewelry – add both naturalism and
movement to the design.
THE COMMERCIAL NATURE OF THE PIECE
is emphasized by the use of tiny rose-cut
diamonds to border the green enamel leaves,
so allowing the salesman to add the appeal
of diamonds to that of fashion.

Length 2¼in/7cm  \$D

# Aquamarine pendant

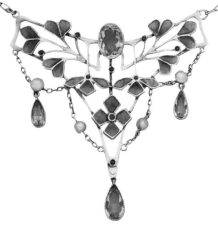

*A* NOTABLE FEATURE OF THE WORK
*of artist-craftsmen at the turn of the 19th
century was the way that they deliberately avoided
using precious stones in favor of fine
workmanship and subtle colors.
The maker of this necklet has teamed pale sea blue
aquamarines with those natural products
of the sea, pearls, to produce a light and delicate
pendant that incorporates* plique-à-jour
*enamel for the leaves.*
*A*LTHOUGH LARGE AREAS OF THIS TRANSPARENT ENAMEL WERE
*fired over a copper foil backing that was
later removed, smaller areas such as those here can
be produced by combining the enamel powder
with gum of tragacanta, a mixture that holds the
enamel in place during firing. This pretty
jewel is given movement by the pearl-set chain swags
and three aquamarine drops. The maker's mark
"G & I" is at present unidentified.*
Width 2¼in/5.5cm  $D

# Opaline glass spray

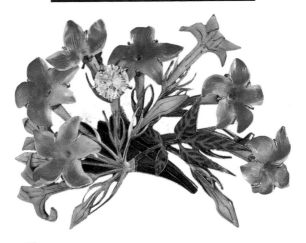

THE ATTRIBUTES OF GLASS HELD GREAT FASCINATION
*for jewelers in the late 19th century, and Fabergé,
Gallé, and Lalique carried out many experiments
with it. One of the products of these
experiments was the rediscovery of opaline glass,
a pale blue semitranslucent material with a
slight schiller, or sheen, just below the surface.*
IN THIS BROOCH, DATING FROM C.1900, THE GLASS HAS BEEN
*carved and shaped to create a naturalistic
spray of jasmine flowers with gold and enamel buds
and leaves. A slightly incongruous note is
struck by the inclusion of a solitaire diamond; this
was more likely to have been at the insistence
of the purchaser than a component of the original
design. Had the diamond later been removed,
as so often happens when pieces of jewelry go out
of fashion, a restorer would probably have
assumed that the missing stone was a moonstone,
simulating a rain drop, or an opal.*
Width *c.*2¼in/5.5cm  $D

# Scarf clip

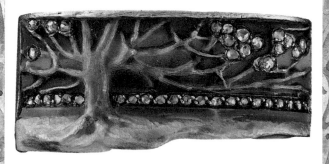

SPAIN IS NOT A COUNTRY CLOSELY ASSOCIATED
*with Art Nouveau jewelry, although Barcelona
was a thriving creative center which accepted such
remarkable creations as the architecture of
Antonio Gaudí. Only one family of jewelers made a
significant contribution to the international
jewelry scene, the two Masriera brothers or,
in Spanish, Masriera Hermanos. Luis, in particular,
showed successfully at international
exhibitions, especially the 1900 exhibition of
Art Nouveau jewelry, where he came under the
influence of René Lalique.*
THE CARE AND DETAIL LAVISHED ON THIS LITTLE
*scarf clip, an item of jewelry no longer
considered worthy of production, was entirely in the
French tradition. The mixture of techniques
include a plique-à-jour enamel sky, shaded enamel
land, a rose-cut diamond horizon, and
a brown enamel tree with rose-cut diamond detail.
The use of the flat-back, triangular-faceted
rose-cut diamonds endows the clip
with pinpricks of light without overpowering
the enamel. It was made c.1905.*
Width 1¼in/3cm   $D

# Pearl choker

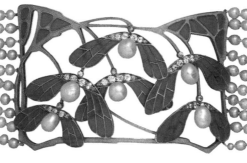

The Art Nouveau style could be adapted
to almost any item of jewelry, and with
its emphasis on naturalism, it warmly embraced that
most natural of gems, the pearl, employing the
vagaries of its shape to great advantage.
In the early 20th century, the vogue for multistrand
pearl necklaces offered great opportunities
to the designer to produce broad but light openwork
panels – a type of design typified by this
choker, made in 1910. The large central panel,
with hanging sycamore clusters decorated
with green and blue enamel, pearls, and diamonds,
supports 10 rows of pearls, linked to
two smaller side panels and then to a matching
clasp. The gold frames of the choker are
curved to the contour of the
neck, and all edges are rounded and polished
to produce a comfortable fit.
Natural pearls, mostly from the Persian Gulf,
were treasured jewels, but they have declined in
public estimation since supply was strangled
by pollution, and the market has been swept by new,
larger, and cheaper cultured pearls.
Width central panel 3in/7.5cm  SF

# French rings

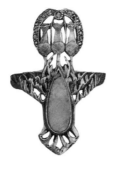 

*In 1900 Paris hosted the Exposition Universelle, so stimulating tremendous interest in French fashion and design. This was a high period for the typically French interpretation of Art Nouveau, and these four rings date from that time.*

*Only two were made by René Lalique, but his influence is discernible in all of them, for he led the return to favor of the opal. The ring top left uses the play of color to suggest a stylized bird feeding on a thistle, while in the ring in the style of Albert Vigan (top right), the opal acts as a pool bordered by bulrushes. Both the lower rings are signed Lalique; the domed one with a central emerald (left) is decorated with cloisonné enamel, while the band ring (right) incorporates plique-à-jour enamel.*

Height all rings ½–1½in/1.5–4cm
$D, $E, $F, $E (clockwise from top left)

# French lapel brooches

**P**ERIOD JEWELRY
*often indicates the
fashions in
dress at the
time:
the soft flowing
lines of traditional
French Art Nouveau
were well suited to the fabrics
and the hour-glass figure
in vogue at
the turn of the
19th century.*

**B**UT FASHIONS WERE
*affected by the growing desire
for a more exotic and
free design, the straight lines
and sharper image being
reflected in these two brooches,
made c.1912. In both, the
stem is severe, but it is softened
with curling tendrils,
and the offset flower heads allow the
brooches to be worn at an angle.*

**I**N THE BACHELOR BUTTON WITH A DIAMOND CENTER (LEFT),
*shades of blue* guilloché *enamel – transparent enamel
over a textured gold surface – are matched
to a sapphire and diamond bud and a single tiny
diamond at the base of the stem.*

Height 3½in/9cm   $C

**T**HE FLOWER ON THE RIGHT RELIES ON GEMS IN THE COLORS
*of the French tricolor – rubies, sapphires, and
diamonds – for its patriotic message.*

Height c.3in/8cm   $B

# Jubilee enamel

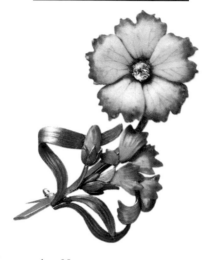

*E*NGLISH *A*RT *N*OUVEAU WAS, IN GENERAL, FAIRLY
*traditional; the current line of jewelry
was adapted by adding whiplash curls and greater
naturalism, but a certain restraint was retained.*
*T*HE *F*RENCH DELIGHT IN THE TECHNICALLY DIFFICULT PROCESS
*of* plique-à-jour *enamel was not widely copied,
for it was recognized that while these pieces could
look wonderful back-lit in an exhibition,
once pinned to cloth or held against the skin, their
beauty was hidden. English enamelers preferred
to exercise the skill of delicately shading the enamel
from one hue to another across the surface,
a difficult and time-consuming art.*
*B*Y 1897, AS *Q*UEEN *V*ICTORIA CELEBRATED 60 YEARS
*on the throne, this style had become so popular in
Britain that it was known as jubilee enamel. This
pink brooch would have been a suitable gift prior to
a trip to London to celebrate the great occasion.*
Height *c.*2½in/6cm  $C

# Guilloché enamel

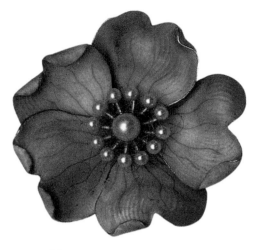

NATURALISM WAS OFTEN TAKEN
*to extraordinary lengths, with artists' workbenches
strewn with fresh flowers each day in
order that the detail in their designs should be
utterly true to nature.*

THIS DELIGHTFULLY OBSERVED AND DECEPTIVELY SIMPLE
*flower brooch, dating from c.1900, called on
every skill of the goldsmith. Each petal
was individually fashioned to present a flower just
entering its period of greatest beauty.
The petals were enameled using the transparent
guilloché technique, and the surface detail was
hand-engraved to allow a varied thickness
of enamel and depth of color.*

ADDITIONAL PAINTING EMPHASIZED THE VEINING WITHIN
*the delicately shaded enamel, and the pearl-set
center avoided any desire for extravagance, creating
a jewel suitable for any occasion.*

Width *c.*1¼in/3cm   \$C

# Hair comb I

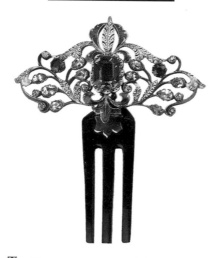

THE GIULIANO FAMILY OF NAPLES IS BEST
known for the work of Carlo, who specialized
in reproductions of antique and Renaissance styles.
He was established in London in the mid-1860s
and set up his own workshop in 1875. Carlo's
brother Frederico opened competing premises where,
in 1883, he was joined by his son Ferdinand,
who made this hair comb c.1900.

AN ART NOUVEAU SHAPE WAS COMBINED WITH RENAISSANCE
coloring to create a reasonably priced jewel
by using a pink paste – a specially manufactured
glass – together with garnets and chrysoberyl.
The surround of tiny diamonds is bordered by the
favorite Giuliano black and white piqué
enamel of tiny black dots on a white ground.
The jewel is secured to the tortoiseshell
hair comb by a screw, allowing it to be detached
and put to alternative use.
Width jewel c.2½in/6cm  $D

# Hair comb II

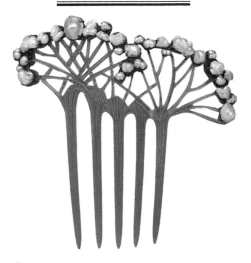

*Boundaries between fashion movements*
*often become blurred as influences are carried from*
*country to country and school to school.*
*Fred T. Partridge, who created works in brass,*
*shell, horn, and steel, mostly with a*
*Gallic influence, was a member of C.R. Ashbee's*
*English Guild of Handicraft which was*
*established in 1888, and as such his work could*
*be categorized as representative of*
*the Arts and Crafts Movement.*
*This carved and steamed horn comb, however,*
*made by Partridge c.1895 is in the best Art Nouveau*
*tradition. The flower heads of this umbelliferous*
*plant are represented by baroque pearls –*
*odd-shaped white to gray natural pearls that were*
*favored by the naturalist designers,*
*who appreciated that they could be used without*
*enhancement or interference.*

Width 4in/10cm  $C

# Cabochon beryl pendant

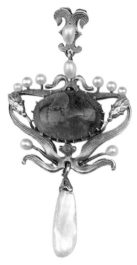

*F*RESH APPROACHES TO JEWELRY DESIGN CREATED
*opportunities not only for craftsmen, but also for*
*suppliers of gems. While traditional pieces had*
*faceted and accurately proportioned precious stones,*
*Art Nouveau encouraged the use of stones that*
*retained their natural appearance.*
   *E*MERALD, A VARIETY OF THE BERYL FAMILY, OWES ITS
*vivid green color to minute traces of chromium*
*in its atomic structure; when the amount of*
*chromium is insufficient, the material is classified*
*as green beryl. This lacks brilliance but, cut as a*
*cabochon, it displays a satisfying watery*
*green color and natural internal structure, which is*
*here matched by the freshwater drop pearl.*
   *S*ET IN A FREE-FLOWING TEXTURED GOLD AND PEARL MOUNT,
*this pendant, dating from c.1900,*
*encapsulates the natural world of gems.*
**Length 1¾in/4.5cm   $B**

# Diamond pendant

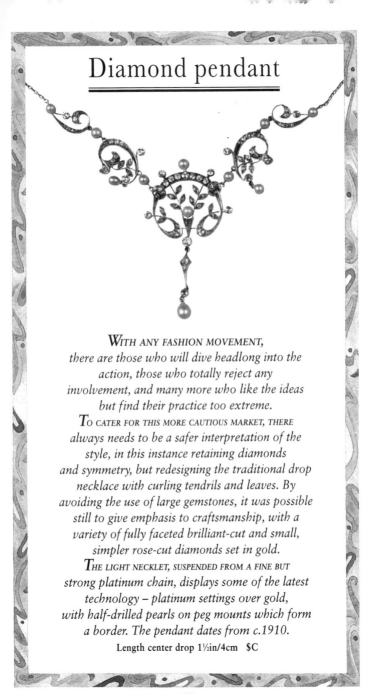

**W**ITH ANY FASHION MOVEMENT,
*there are those who will dive headlong into the
action, those who totally reject any
involvement, and many more who like the ideas
but find their practice too extreme.*

**T**O CATER FOR THIS MORE CAUTIOUS MARKET, THERE
*always needs to be a safer interpretation of the
style, in this instance retaining diamonds
and symmetry, but redesigning the traditional drop
necklace with curling tendrils and leaves. By
avoiding the use of large gemstones, it was possible
still to give emphasis to craftsmanship, with a
variety of fully faceted brilliant-cut and small,
simpler rose-cut diamonds set in gold.*

**T**HE LIGHT NECKLET, SUSPENDED FROM A FINE BUT
*strong platinum chain, displays some of the latest
technology – platinum settings over gold,
with half-drilled pearls on peg mounts which form
a border. The pendant dates from c.1910.*

**Length center drop 1½in/4cm   $C**

# Liberty & Co.

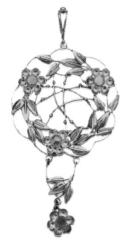

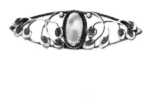

*Demonstrating an ability both to predict and to shape public enthusiasm, in 1875 Arthur Lasenby Liberty opened his store in Regent Street, London, as an Oriental emporium. He soon expanded into decorative arts and jewelry, launching the distinctive "Cymric" line based on the designs of Archibald Knox in the late 1890s.*

*Liberty employed many leading British designers, but insisted their work should carry only the Liberty name, so creating interesting problems of attribution. Most of the jewelry reflected the ideal of individual, hand-made appearance, although many pieces were produced that were similar in style.*

*The pendant, in gold, silver, and rose-cut diamonds, retains its original fabric-covered fitted case, while the brooch has a central blister pearl, cut from the shell lining of the pearl oyster, in a simple silver and gold floral border. Both date from c.1905.*

Length pendant *c.*2½in/6cm  $C; brooch *c.*1½in/3.5cm  $A

# Rock crystal necklace

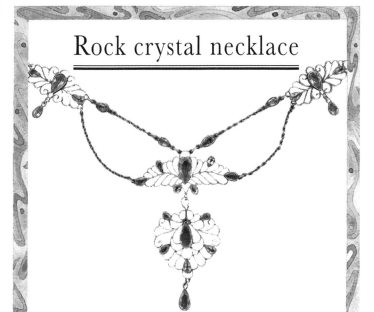

A RTHUR G ASKIN AND HIS WIFE G EORGIE
*were involved with the Arts and Crafts Movement
based on the Birmingham School of Arts,
and they produced individual hand-crafted pieces
that took their inspiration from a variety of
Classical and ethnic subjects.*
T HIS NECKLACE CAN BE RELATED TO B ERLIN IRONWORK
*of the 19th century; yet, with its scrolling floral
outline and use of inexpensive colorless faceted rock
crystal, it is not out of place in any collection of Art
Nouveau items. It may be seen as a bridge between the
flamboyance of French Art Nouveau, the austerity of
the German* Jugendstil, *and the modernism
of the Austrian Wiener Werkstätte.*
T HE G ASKINS SELDOM SIGNED THEIR WORK, BUT THIS
*necklace is still in its original case and in 1902 was
illustrated in the contemporary magazine devoted to
the decorative arts,* The Studio, *p. 216, vol. 26.*
**Length central pendant 2¾in/7cm  $B**

# Gem palette pendants

NATURALISM EMBRACES NOT ONLY THE
*reproduction of nature, but also the display of the
variety of its products. So it is fitting that
many jewels used a range of colored gemstones
besides the usual diamond, ruby, and so on.*
THESE TWO PENDANTS, DATING FROM 1910, REPRESENT A
*considerable international trade, for among
the stones used are green peridot from the Isle of
St. John in the Red Sea and pink topaz from Ouro
Preto in Brazil (left); pale blue aquamarines from
Minas Gerais in Brazil, tiny, bright green
demantoid garnets from the Russian Urals, and
diamonds from southern Africa (right).*
ONCE SELECTED AS OF GEM QUALITY, THE STONES WERE CUT.
*With the aquamarines, the jeweler formed
his design around the prepared stones, while the
varied leaves on the left were cut
specifically to fit a preconceived design.*
**Length left 2¾in/7cm  $B; right 2½in/6.5cm  $B**

# Off-the-shelf jewels

By 1910, THE ART NOUVEAU STYLE HAD
*developed well-defined basic forms, and these
pendants of moderate quality are typical window
stock of a high-street jeweler at that time.*
BOTH ARE NOW DESIRABLE EXAMPLES OF PERIOD JEWELRY,
*eagerly sought and rising rapidly in value. The
pendant on the left is mounted in 15-carat gold and
set with split pearls – little seed pearls sawn in half
to provide two flat-backed, easily set gems.
The settings are decorated with raised gold grains to
carry the design through the foliate scrolls, with
drop-cut green peridot and topaz adding color.*
Length 3in/8cm  \$B

THE PENDANT ON THE RIGHT IS LIGHTER AND USES LOWER-
*grade 9-carat gold, with garnets, half pearls, and
the now rare and expensive bright green demantoid
garnets – a by-product of gold panning in the
Ural Mountains at the end of the 1800s.*
Length c.2½in/6cm  \$B

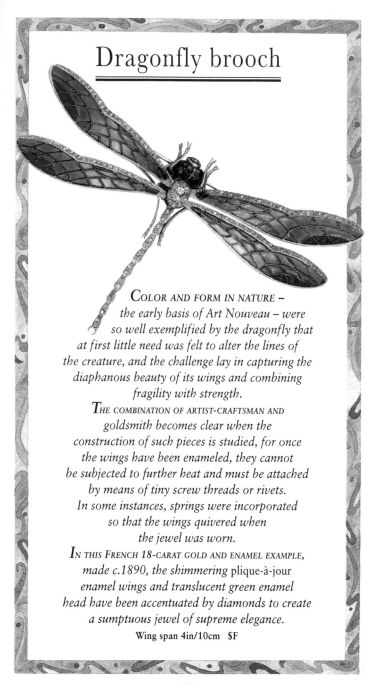

# Dragonfly brooch

COLOR AND FORM IN NATURE –
*the early basis of Art Nouveau – were
so well exemplified by the dragonfly that
at first little need was felt to alter the lines of
the creature, and the challenge lay in capturing the
diaphanous beauty of its wings and combining
fragility with strength.*

THE COMBINATION OF ARTIST-CRAFTSMAN AND
*goldsmith becomes clear when the
construction of such pieces is studied, for once
the wings have been enameled, they cannot
be subjected to further heat and must be attached
by means of tiny screw threads or rivets.
In some instances, springs were incorporated
so that the wings quivered when
the jewel was worn.*

IN THIS FRENCH 18-CARAT GOLD AND ENAMEL EXAMPLE,
*made c.1890, the shimmering plique-à-jour
enamel wings and translucent green enamel
head have been accentuated by diamonds to create
a sumptuous jewel of supreme elegance.*

Wing span 4in/10cm  $F

# Grasshopper brooch

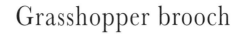

MANY OF THE SMALLER INSECTS, SUCH AS THE *grasshopper, display a beautiful variety of subtle colors, which were faithfully reproduced by the craftsman who created this brooch c.1910.*
THE MAKER'S COMPLEX TASK BEGAN WITH FORMING THE *basic shape, manufactured in a gold alloy specially prepared as a suitable base for the enamel. This was then textured and detailed before the vitreous enamel powder was applied. The powder, in suspension, was painted onto the body, and at this point, the enameler's skill and judgment were of paramount importance, for in the process of firing the enamel the apparent color of the original material alters considerably. Consequently, many experiments would have been needed to achieve the desired hue and degree of transparency. After a successful firing, the enamel had to be polished and the brooch passed to the gem setter to add the diamonds and emeralds.*
SUCH INDIVIDUALLY HAND-CRAFTED PIECES ARE WELL *worth seeking out, for many are still considerably undervalued by comparison with the cost of such dedicated labor today.*
Length 2in/5cm  $B

# Fob watches

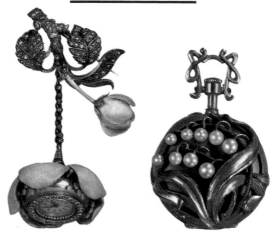

NATURALISM AND ART NOUVEAU LENT THEMSELVES *readily to jewelry design, but incorporating more practical functions imposed complex restraints upon the designer. The examples above demonstrate two very different approaches to the problem of producing a stylish watch – the one on the left totally broke with tradition, while the other adapted a standard casing.*

THE DOG ROSE PENDANT WATCH, MADE BY TIFFANY & CO., *New York, c.1889, was beautifully detailed, down to yellow pollen markings on golden stamens. Even the tooled-leather fitted case was shaped in a curious undulating organic form. This watch is very similar to one exhibited at the Paris Exposition Universelle of 1889 and is from the same group of jewels as the orchid shown opposite.*

BY CONTRAST, THE SWISS FOB, DATING FROM C.1900, *although beautifully crafted, was firmly restrained by the basic watch shape.*

Height left 3in/7.5cm  $G; diameter right 1½in/4cm  $D

# Tiffany orchid

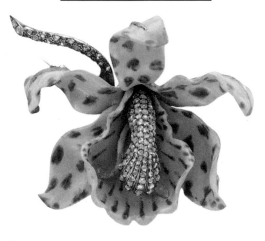

*THE SERIES OF EXPOSITIONS UNIVERSELLES IN PARIS in the late 1800s demonstrated the rapidly changing fashions of the era, from the naturalism of 1889 to the full flowering of Art Nouveau by 1900, which was subsequently blighted by World War 1.*

*AT THE 1889 EXPO, TIFFANY & CO. EXHIBITED 25 ORCHID brooches, designed by Paulding Farnham, its chief designer, and made entirely from American materials. The Tiffany display was awarded a gold medal and established the company internationally.*

*THE ORCHID ILLUSTRATED, CATTLEYA VELUTINA 'Schilleriana,' is found in Brazil and was accurately copied in gold, silver, enamel, rubies, and diamonds from preserved specimens. A unique brooch with a provenance such as this is every collector's dream, and when one is offered for sale, it excites tremendous interest. This brooch and another from the same series were sold in 1994 for more than $75,000 each.*

Width *c.*2in/5.5cm  $G

# Curvilinear gold brooch

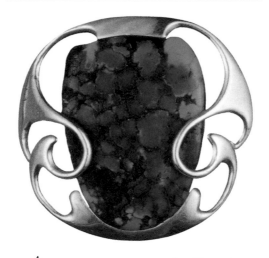

*As the popularity of the Art Nouveau
style spread, the need arose to cater to all
levels of the market. Several companies responded by
producing a wide selection of silver and gold items
of varying quality. A leader in this field was
Murrle, Bennett & Co., established in 1884 in
Pforzheim, Germany. Until World War I,
it produced work from a wide range of artists and
designers from Pforzheim and Darmstadt
which was marketed in Great Britain through
various outlets, including Liberty & Co.
This curvilinear gold brooch is an excellent example
of its production c.1900. It was well designed
in gold and turquoise, with strong styling, yet
it remained an easily wearable piece.
Turquoise with black matrix inclusions was,
at the time, considered more desirable than the more
precious but less interesting plain blue stone.*

Width *c.*1¼in/3cm  $B

# Opal pendant

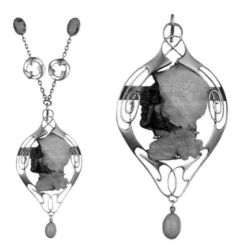

*A* CURVILINEAR DESIGN WITHIN A RESTRAINED
*traditional outline is evident in this pendant made by*
*Murrle, Bennett & Co. c.1910. As in so much*
*Art Nouveau jewelry, the choice of white opal,*
*with its soft, changing colors, was*
*influenced by the vogue for naturalism.*

*O*PAL FORMS AS A SILICA SOLUTION FLOWING OVER AND
*through a sandstone bed, and it often solidifies as a*
*thin skin on the base rock. Here, such a piece has*
*been worked to use the rock as the profile, dressed*
*in opal. Both rock and opal are fragile, so great care*
*was required from both the cutter and the setter,*
*and the center stone is a fine example of the lapidary*
*art. A clever design feature was the use of the*
*side curls as guards to protect the stone.*

*T*HE SUPPORTING STONES AND DROP ARE CUT
*en cabochon, a simple rounded and polished shape*
*that gives maximum effect to the play of color.*

Length pendant *c.*2½in/6cm   $D

# Mother-of-pearl pendant

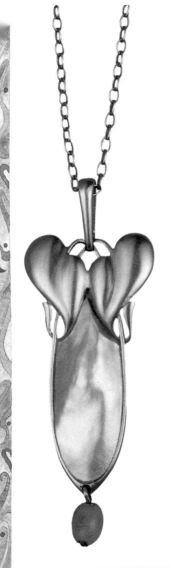

*AT THE TURN OF THE 19th century, little thought was given to the issue of conservation, and people were happy to give expression to their love of nature by wearing tortoiseshell, ivory, bone, horn, coral, and other more exotic organic materials.*

*POSSIBLY ONE OF THE LEAST contentious materials today is mother-of-pearl, the hard, smooth, iridescent inner lining of the shells of various mollusks, including the pearl oyster, abalone, and river mussel.*

*THE SHEEN OF POLISHED mother-of-pearl brings to life this pretty floral pendant with a gold twin-leaf top and a turquoise drop. Another piece from the extensive Murrle, Bennett & Co. line (c.1900), it would have made a charming, fashionable gift for a young lady.*

Height 1¾in/4.5cm  $B

# Brangwyn enamel pendant

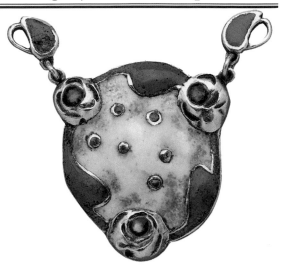

MANY ARTISTS HAVE TURNED THEIR HAND TO
*jewelry design, with varying degrees of success.*
*Sir Frank Brangwyn conceived his designs as a*
*protest against the machine-made work of Victorian*
*times and the use of gaudy gemstones.*
*His insistence that all components of a jewel should*
*combine to form a carefully considered and*
*wrought whole was entirely in tune with the Art*
*Nouveau movement and was recognized as*
*such by the retailer Samuel Bing.*
ON DECEMBER 26, 1895, BING OPENED HIS NEW GALLERY
*for Art Nouveau at 22, rue de Provence, Paris, thus*
*promoting and popularizing the new movement.*
*Brangwyn designed at least four pieces for*
*Bing's Maison de l'Art Nouveau, but this gold and*
*multicolored enamel pendant, dating from*
*c.1895, is the only known survivor.*
Width 1¾in/4.5cm  $D

# Peacock brooch

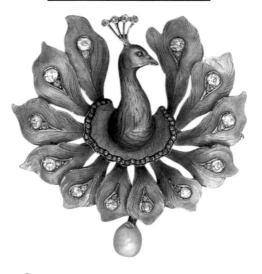

*S*YMBOLIZING BOTH THE BEAUTY OF NATURE
*and the vanity of the male, the glory of a
displaying peacock has attracted artists down the
ages. It is represented in 18th-century
jewelry by large, yet delicate, gem-set feather
brooches and appears in this example from c.1890
as a slightly surreal flower-head arrangement.*
*T*HIS FINE EXAMPLE OF THE ARTIST'S VISION TRANSLATED
*into three dimensions challenges the observer
to decide exactly what is depicted. Decorated with
shaded blue and green guilloché enamel
and with each feather-petal set with two small
diamonds, the realistically modeled head
rises proudly to its four-stone diamond crest.
The baroque drop pearl is, perhaps, redundant in
this design, but it was an established
element of Art Nouveau jewels.*
Height *c.*1¾in/4.5cm   $D

# Peacock pendant

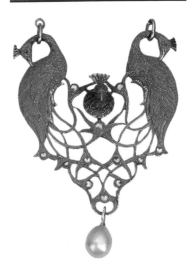

*ALMOST ALL PARISIAN ART NOUVEAU JEWELERS employed peacock motifs in their designs, but they were a particular favorite of René Foy. Like Lalique, he was a notable exhibitor at the Paris 1900 Exposition, where his display included a diadem in the form of an enameled peacock feather which curled over the hair. Little written record of Foy's activities exists, which adds significance to the fitted case for this jewel, since it records his address: 12, rue Legendre, place Malesherbes.*

*SUSPENDING THIS INTRIGUING PENDANT, MADE C.1900, FROM the necks of two birds adds a disturbing element to a design full of thought-provoking surprises: in the center is a third peacock, with its head reaching forward from the interlaced green foliage. The workmanship is superb, with shaded translucent enamel plumage and detailed modeling.*

Height 3in/8cm   $F

# Swan brooches

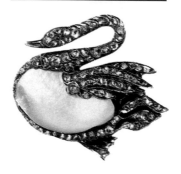

*Following a Renaissance tradition, the designer of the brooch above, when presented with this large baroque pearl, let his imagination explore the possibilities of its shape and texture. Bearing in mind the pearl's watery birthplace and serene color, the body of a swan was an appropriate choice, with the wing probably concealing a flaw in the upper part of the pearl. To maintain a limpid quality, the details are set with diamonds mounted in silver, the only color being the eye, beak, and feet.*

Width *c*.1¼in/3.5cm  $D

*The brooch below, although made only 10 to 15 years later, c.1900, is notably different in style, setting the swans on an imaginary pond bordered by convoluted rush leaves.*

Width 1½in/4cm  $B

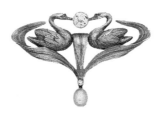

# Birds on branches

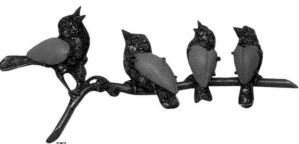

*THE VICTORIANS LOVED SYMBOLISM,
and books were published on the language of gems;
they also delighted in brooches modeled as
animal caricatures. By the 1890s, this whimsy was
frowned upon; but under the guise of naturalism, the
maker of this brooch has incorporated sentiment,
humor, and realism. While there was a
wide selection of jewelry to mark an engagement,
a wedding, or the birth of a child, the choice of
a significant piece for the mother of an established
family would have been more difficult. But these
turquoise, diamond, and ruby bluebirds with their
chicks would have had instant appeal.*

Width 2in/5cm   $C

*THE GOLD SWALLOWS GATHERED ON THEIR DIAMOND-SET
perch perhaps conveyed a different message as they
contemplated migration to warmer climes.*

Width *c.*1¼in/4.5cm   $C

# Gorham fob watch

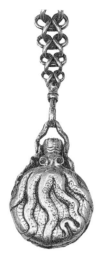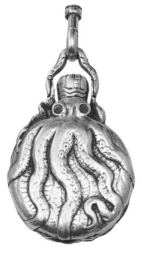

*E*STABLISHED IN *1815* IN P*ROVIDENCE*,
*Rhode Island, the Gorham Manufacturing Co.
made a variety of plated wares, silver, and jewelry.
It produced a variety of Art Nouveau silver and
jewelry under the title Martele, as well as pieces
such as this idiosyncratic case for a fob watch, made
c.1890 for Tiffany, whose name appears on the
dial and movement. This combination of a quality
timepiece with clever silversmithing created a
functional object that is a delight to handle.*
*T*HE OCTOPUS WAS CAREFULLY MODELED, EACH TENTACLE
*engraved with sucker detail (now worn through use),
and with enameled eyes that brought the creature
to life. The watch was suspended from a period
silver fob chain attached to a bar which would be
placed in the lapel buttonhole, allowing the octopus
to scuttle to the safety of its watch-pocket lair.*
Diameter *c.*1½in/3.5cm   $C

# Griffin brooch

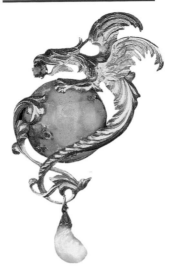

*THE GRIFFIN, A FABULOUS CREATURE EMBLEMATIC
of watchfulness and courage, was modeled
as guardian of the globe in this brooch made c.1900.
The clever rendering carries the tail into flowing Art
Nouveau floral scrolls that balance the forceful
posture of the eagle-headed beast. Carved in gold, it
holds a garnet in its beak and protects a polished
hemisphere of variscite, a blue-green stone native
to Utah and Nevada, with natural matrix inclusions
that perhaps suggested the design.*

*AS WAS EVIDENT FROM TIFFANY'S ORCHID SERIES AT THE
1889 Expo, there was at the time a strong
desire in the United States to promote its
gem resources. Indeed, this brooch may be entirely
American, with gold from Colorado, scene of
the 1860 gold rush, and a characteristic Mississippi
River pearl, product of the pearl mussel.*

Length 2¾in/7cm  $B

# Longines pocket watch

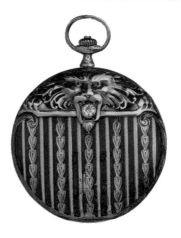

*A DRESS POCKET WATCH WAS AN ESSENTIAL
for the well-turned-out Victorian gentleman.
It slid into the vest pocket, secured by a gold or
platinum chain, and was balanced at the other
end by a seal fob, cigar cutter, or penknife.
While most were of high quality, they were usually
functional items, with simple engine-turned
or floral engraved cases. But not all were as innocent
as they seemed; extreme examples hid erotic scenes
in enamel beneath a plain back cover.
THIS TIMEPIECE, DATING FROM c.1900, LACKS SUCH
titillation, although turning from the plain white
enamel dial, the ferocity of the chased gold monster
devouring a diamond comes as a considerable
surprise. The Swiss-made case, decorated with
white and blue enamel, would have been
commissioned by Longines, which made the fully
jeweled movement and advertised its product
as "The world's most honored watch."*

Diameter 2in/5cm  $C

# French rings

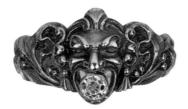

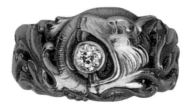

Nothing is more frustrating for the
jewelry historian than to be presented with a
fine-quality period piece only to find that the maker's
name is illegible or unrecorded. Both problems are
present in these two rings, made c.1900.

The ring with the mask of a satyr holding a brillant-
cut diamond in its bared jaws, and with ribbon
and laurel-leaf shoulders, is clearly stamped inside
the shank with a typical French maker's mark –
a small lozenge enclosing the initials E.V. – but as
yet the identity of this maker is unknown.

In the wolf's head ring, the maker's mark is weakly
struck and so worn that it is illegible except,
possibly, to a metallurgical laboratory. The design
of this ring is notably sculptural, and it would
not be surprising to encounter it in a Gothic church,
where the wolf symbolized evil, combining
ferocity, cunning, and greed – probably not what
the stylish wearer intended to convey.

Width both rings 1in/2.5cm $C

# Chimera

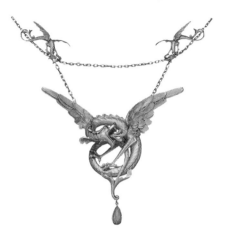

*F*ROM *H*OMER'S *I*LIAD COMES THIS FIRE-BREATHING *dragon, the Chimera, slain by Bellerophon and returned to savage life in 1895 by the maker Plisson & Hartz in chased matted gold. It writhes in Art Nouveau scrolls with outspread wings, the neck chain held at either side by two smaller winged dragons and with an opal drop, probably replacing a baroque pearl. The brooch below, also dated c.1895, may be from the same workshop.*

*S*UCH BROCHES-CHIMÈRES, CATERING TO THE PUBLIC LOVE OF *controlled horror, became an established French fashion, which continued well into the 20th century.*

Width pendant 3¾in/9.5cm  $E; brooch c.2¼in/5.5cm  $C

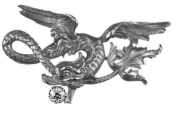

# Chatelaine

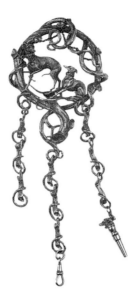

THE ART NOUVEAU MOVEMENT IS RECOGNIZED AS
*having found its identity in 1895, but the various
elements that combined to create the style can
be seen emerging from c.1850. The meaningless
decoration of any vacant surface, which had been
prompted by popular enthusiasm for nature,
was detested by the art critics, and publications such
as Owen Jones's* Grammar of Ornament *led to
a new appreciation of form and function.*
THE ENTWINED, FREE-FLOWING NATURALISM OF THIS WATCH-
*chatelaine from c.1870 superbly integrates purpose and
design. There is, perhaps, a hint of nostalgia in the
group of greyhounds, the favorite breed of Queen
Victoria's consort, Prince Albert, whose death in 1861
robbed Britain of a great champion of design.*
Width *c.*2¼in/5.5cm  $D

# Art Nouveau imagery

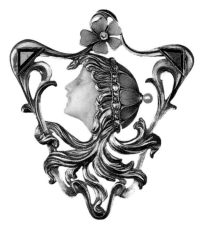

THE IMAGE MOST IMMEDIATELY ASSOCIATED WITH
*Art Nouveau is probably the profile of a maiden,
with flowing, wind-whipped hair. This classic
French brooch, made c.1905, combines various
techniques: the girl's profile, carved from flesh pink
coral, is framed in chased and engraved gold,
with enamel, pearls, diamonds, and sapphires.*
HER FORGET-ME-NOT FLORAL CAP IS RIMMED WITH DIAMONDS
*and topped by a pearl, a slightly concealed use
of the flower which is complemented by
the fully open flower above; both are enameled,
with delicately painted shading and veining.
The scrolling frame blends well with the girl's
binding tresses, but a jarring note is struck
by the angular sapphires, possibly added later to
conceal a defect or to modernize the piece.*
THIS IDEAL OF A FREE FEMININE SPIRIT OWES MUCH TO THE
*influence of Pre-Raphaelite paintings and to growing
feminine self-expression and emancipation.*
Width *c.*2¼in/5.5cm  $D

# Lalique glass brooches

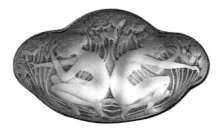

RENÉ LALIQUE'S ART NOUVEAU JEWELS ESTABLISHED *him as the supreme master of sensuous fantasies in exotic combinations of horn, ivory, glass, enamel, pearl, opal, and moonstone. Lalique strove constantly for new textures and light effects, and from 1908 worked exclusively in glass. This allowed him to explore the shadowy, semiconcealed female form, which appeared and faded magically as light intensity altered and angles shifted.*

BY MOLDING THE FIGURES INTO THE REVERSE OF THE GLASS *panels shown here – the one stained blue, the other colorless – then etching and polishing the surfaces and mounting the panels over softly colored mirror foil, Lalique has created mystical scenes of deceptive simplicity. Mounted in gilt metal, each panel, made c.1910, bears Lalique's signature.*
Width both brooches *c.*2¼in/5.5cm  $D

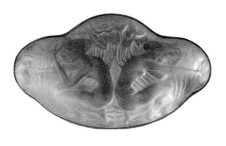

# Medusa brooch

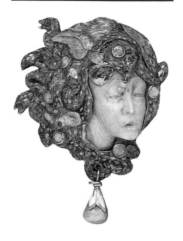

*THE 1914–18 WAR IS GENERALLY CONSIDERED
to have killed the appreciation of individually
handcrafted jewels, replacing it with the machine-
driven modernistic approach displayed at
the Exposition Internationale des Arts Décoratifs
et Industriels Modernes, held in Paris in 1925.
There were, however, pockets of resistance, as shown
by the craft revival led by Sybil Dunlop and
George Hunt, who both used naturalism as a basis
for enamel and stone-enriched jewels.
HUNT AVOIDED ALL MODERN INFLUENCE WHEN, C.1920,
he made this brooch modeled on the head of Medusa,
the Gorgon of Greek myth whose glance turned
men to stone – an oddly popular motif from Roman
to 20th-century jewelry. The staring eyes and
hair of writhing snakes have been interpreted to create
a slightly sad figure, with a carved ivory face
and a gold and blue-green enamel surround set with
opals and a typical baroque drop pearl.*

Length *c.*2½in/6cm $D

# Serpent brooch

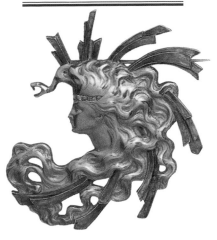

*A* FAMOUS PHOTOGRAPH TAKEN C.*1895* SHOWS
*the celebrated French dancer and courtesan Liane
de Pougy wearing a set of striking René Lalique
jewelry. It includes a large pendant and a
silver, enamel, and chrysoprase headband modeled
as a winged dragon, with its head and neck
reaching ferociously forward.*

*T*HE IMAGE IS IMMEDIATELY RECALLED BY THIS BROOCH,
*in the form of a woman's head dominated by a
striking serpent. It dates from about the time of the
photograph and is an unsigned example of high-
quality commercial work that exploits the popularity
of Lalique's famous theatrical jewels.*

*T*HE ROSE-CUT DIAMOND HEADBAND ADDS A TOUCH
*of opulence, but the rather harsh spiky
enamel surround appears out of character and must
have resulted in many a snagged dress, a
complaint more commonly associated with the
Sputnik jewels of the 1960s.*

Height *c.*2in/5cm  $C

# Gold brooches

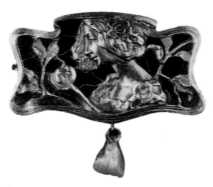

*THE 1900 PARIS EXPO INFLUENCED THE ART
Nouveau movement greatly, the list of exhibitors in
the jewelry pavilions reading like a Who's Who
of the designers and makers of the period.
Both these brooches date from c.1900.*

*THE ONE ABOVE, WITH PLIQUE-À-JOUR ENAMEL, AN ORGANIC
border, and a baroque pearl, reflects the ideals of
Art Nouveau and is highly symbolic: the girl with a
golden apple is possibly Venus, accepting the gift
from the aptly named Paris, or Eve.*

*BELOW IS A BROOCH BY GUSTAVE SANDOZ, WHO WAS BOTH
an exhibitor and on the jury of the 1900 Expo – an
important advertisement for his shop on Paris's rue
Royale. The slightly unusual use of diamonds
and rubies was, possibly, at the request of a client.*

Width both brooches 3in/8cm   $C (above); $D (below)

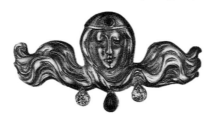

# Fix pendant

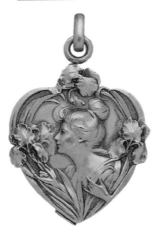

I<small>F, WHEN STUDYING A PIECE OF ART NOUVEAU</small>
*jewelry, you see on the reverse a small panel bearing*
*the word "Fix," be very cautious. This company*
*was the costume jeweler of the day, producing*
*a line of well-designed items within the limitations of*
*die-struck production (this pendant from*
*c.1900 is typical) and applying a substantial plating*
*of gold to the base-metal body to achieve*
*a rich and convincing appearance.*

I<small>T IS IRONIC THAT SUCH ATTRACTIVE EXAMPLES OF AN ART</small>
*form based upon the rejection of mass production*
*should be machine made, but upon consideration*
*one realizes how the style has been simplified*
*to an easily recognizable image, without any of the*
*characteristic piercing, chasing, and enameling*
*that consumed the craftsman's time.*

A<small>NY COLLECTION OF ART NOUVEAU SHOULD INCLUDE AN</small>
*example of Fix jewelry to illustrate how the lower*
*end of the market responded to the fashion.*

**Height 2in/5cm  $A**

# Lalique gold pendant

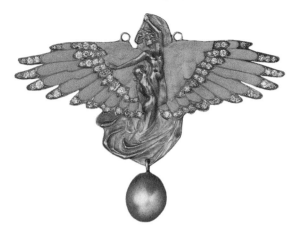

RENÉ LALIQUE'S DISPLAY OF DARING FEMALE
*figures and fine enamels at the Paris Salon of 1894*
*established a basis for his work over the next decade.*
*This early example, dating from 1895, features*
*entwined figures, amid swirling drapery, striving*
*for freedom – symbolized by the outspread*
*enamel wings detailed with diamonds. The carved*
*central panel of polished and textured gold is*
*counter-enameled – enameled on the reverse – with a*
*different scene in shaded pink, and the pendant*
*terminates in a large gray baroque pearl.*

BETWEEN THE WARS, LALIQUE'S JEWELS FELL FROM FAVOR,
*and many of the gem-set pieces were broken up to*
*reuse the gems. In 1969, a review of the auction*
*season proudly declared that a diamond fern*
*leaf tiara by Lalique had sold for £250; but by 1989,*
*when this pendant was auctioned, Lalique was once*
*again recognized as a leading figure in the history*
*of jewelry, and it realized $63,000.*

Width *c.*3¼in/8.5cm  $G

# Dragonfly maiden

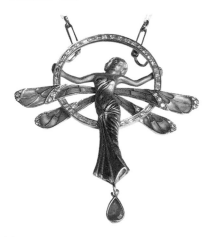

*T*HE 19TH CENTURY HAD BEEN A TIME OF
*industry, empire building, and armed might, with
male domination "by right" in almost all aspects of
life. At the turn of the century, women's perception
of their role in political, academic, and domestic life
was changing markedly, and these undercurrents
in society were reflected in the symbolism
of popular jewelry of the day.*

*I*N ADDITION TO BEING EXTREMELY PRETTY, THIS DRAGONFLY
*woman pendant, made c.1910, reflects the insect's
metamorphosis from drab earth-bound larva
to soaring creature of freedom, beauty, and self-
expression. Modeled in gold, with* plique-à-jour
*enamel and diamond wings, the girl swings in a hoop
set with baguette-cut diamonds, a luxurious
and sophisticated choice, since these rectangular-cut
stones present an unbroken line of white light
without the harshness of the brilliant cut. A cabochon
emerald is suspended beneath the pendant.*

Length *c.*2¼in/5.5cm   $D

# Fouquet & Mucha chain

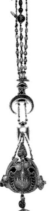

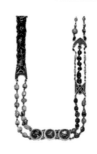

THIS REMARKABLE *corsage ornament is a product of the partnership between Georges Fouquet's Paris workshop and the Czech painter Alphonse Mucha. In 1895 Mucha designed the decoration of Fouquet's shop at 6, rue Royale in Art Nouveau style, and later designed jewels for Fouquet. The first was the famous serpent bracelet for Sarah Bernhardt, shown with this chain at the 1900 Paris Expo.*

DESIGNED TO BE WORN ACROSS THE SHOULDER, THE JEWELED *gold chain supports two different terminals: a drop with enamel, and baroque pearls balancing twin Mucha miniatures on mother-of-pearl, which are suspended from a* plique-à-jour *enamel lotus blossom. Baroness de Guestre bought the ornament, but wore only the lotus blossom as a brooch, finally selling it and the miniatures to a dealer. Only in 1980 did all the parts come together again after the original design was shown at a Mucha exhibition.*

Total length 5ft 2½in/1.59m   $G

# Masriera pendants

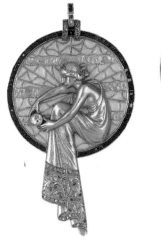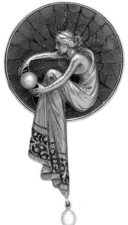

*SUCH WAS THE EFFECT OF THE ART NOUVEAU jewelry displayed at the Paris 1900 Expo on the Spanish artist Luis Masriera that he is reputed to have returned to Barcelona, closed his store for six months, melted down his entire stock, and reopened with a new selection of Art Nouveau jewels, which were sold out in one week.*

*HIS DISTINCTIVE DESIGNS CONTINUED TO BE PRODUCED UNTIL 1922, when the swing to Art Deco made them unfashionable. But by the 1970s, these designs were again in demand, and the Masriera firm resurrected them and produced more of these high-quality jewels, creating a problem for the collector.*

*THE SAPPHIRE, DIAMOND, AND PLIQUE-À-JOUR PENDANT OF Arachne on the left is signed Masriera Hermanos, a mark used until 1915; the pendant on the right bears the 1970s mark, Masriera y Carreras. There is little difference in quality, but a vast one in value.*

Length left 3in/8cm  $F; right *c*.3in/7.5cm  $D

# Eve

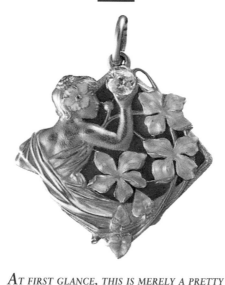

AT FIRST GLANCE, THIS IS MERELY A PRETTY
*pendant of typical Art Nouveau form, depicting a
young maiden in a foliate surround holding aloft
a diamond, and with a* plique-à-jour *enamel
background to her enamel leaf and petal bower.*
FROM WHAT SOURCE DID THE DESIGNER DRAW HIS
*inspiration? Why is the figure holding up a diamond?
Surely not as an ostentatious display of wealth,
for that would be the very antithesis of Art
Nouveau ideals. So the diamond must be there
to convey some other, special, meaning.*
THIS LOVELY GEM IS A PRODUCT OF NATURE,
*as was the tree full of apples that tempted Eve. In
this pendant, made c.1900, Eve is plucking the
forbidden fruit – an expression
of independence and rebellion well understood
by women as the new century dawned.*
Width 2¼in/5.5cm  \$D

# Feminine forms

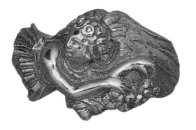

Aurora, goddess of the dawn and sister of
Helios, the sun god, rose every morning to lead him
into the heavens. This was a popular subject for
17th-century ceiling and fresco painters. Indeed, the
portrait of Aurora on the ring above derives
from Guido Reni's fresco of 1613–14 in the Casino
dell'Aurora of the Palazzo Rospigliosi in Rome.

The dawn of the new day could also be interpreted as
the dawn of the new century, making this an
eminently suitable subject for an Art Nouveau jewel.
The goddess is depicted holding a garland of flowers,
while her swirling dress and outstretched wings
carry the design right around the hoop, inside which
is engraved a monogram and the date 6-5-02.

Also expressive of freedom and sensuality, a sleeping
naked female figure with flowing hair forms
the hoop of the ring below. This one was probably
designed c.1900 by Jean Louis Bonny.

Width both rings c.1in/2.3cm  $D

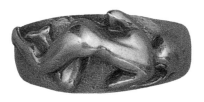

# Descomps brooch

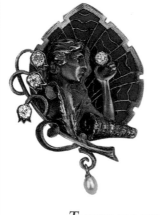
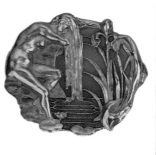

*T*RAINED AS A SCULPTOR, MEDALIST,
*and engraver with the Parisian jeweler Falguières,*
*Emanuel-Jules Joe Descomps created fine Art*
*Nouveau jewels and objects of virtu.*

*D*ESCOMPS'S SCULPTURAL ABILITY IS REVEALED IN
*the signed brooch on the right, made c.1900.*
*The gold is carved, chased, and engraved to create*
*a three-dimensional pool-side scene, which has*
plique-à-jour *enamel for the water and a*
*three-colored sunset in the background, giving*
*an effect of natural tranquillity.*

Height *c.*2in/5cm  \$E

*T*HE LEFT-HAND BROOCH, DATING FROM C.1905,
*is much more specific in subject and exploits the*
*common theme of a maiden holding up a*
*diamond. But here there is the added symbolism*
*of the horn of plenty, with the lily of*
*the valley and* plique-à-jour *enamel spider's web*
*suggesting both the existence of opportunity*
*and the need for caution.*

Width *c.*1¼in/3.5cm  \$D

# Russian pendant

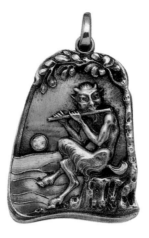

*ALTHOUGH TO RENAISSANCE ARTISTS PAN*
*personified lust, to the ancient Greeks he was a god*
*of woods and fields, flocks and herds. Here*
*he is modeled in a scene of pastoral simplicity,*
*playing his pipe in Arcadia.*

*THE GOLD USED FOR THIS ENAMELED LOCKET-PENDANT,*
*dating from c.1905, has an unusual slightly*
*greenish tinge, an effect created by alloying*
*metals other than copper, for example*
*nickel, iron, or palladium, with fine gold. This*
*technological skill was raised to an art*
*form by Carl Fabergé, the famous Russian jeweler.*
*Although this pendant is not by him, the*
*loop has Russian gold marks of an*
*unrecorded maker – "S.P." – together with the*
*Moscow marks for the period 1899–1908.*

*THIS IS A DELIGHTFUL EXAMPLE OF INTERNATIONAL FASHION*
*modified by a regional specialty and resulting*
*in a beautiful and distinctive jewel.*

Height 2in/5cm   $D

# The hunt

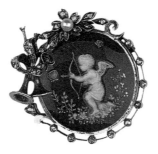

Cᴜᴘɪᴅ ɪs ᴇɴɢᴀɢᴇᴅ ɪɴ ᴛʜᴇ ʜᴏᴘᴇʟᴇss ᴛᴀsᴋ ᴏғ
*pinning down a butterfly with an arrow in the scene
on this brooch (above), made c.1890. It is painted
in opaque white enamel over a background
of transparent red guilloché enamel, which
incorporates gold paillons to form tiny glistening
flowers. The scrollwork borders, set with pearls
and rose-cut diamonds, incorporate crossed horns,
accentuating the piece's hunting theme.*

Width 1¼in/3cm  $C

Pʀᴏᴅᴜᴄᴇᴅ 20 ʏᴇᴀʀs ᴇᴀʀʟɪᴇʀ, ᴛʜᴇ ʙʀᴏᴏᴄʜ ʙᴇʟᴏᴡ ᴄᴀʀʀɪᴇᴅ
*a message from a different age. The love of stag
hunting, encouraged in Britain by Prince Albert, was
captured in this fine stag's head surrounded
by oak leaves and acorns and a hunting horn.*

Width c.1½in/4cm  $B

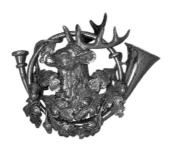

# Medal jewels

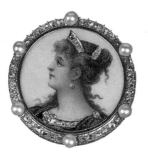

*FASHION BY ITS VERY NATURE CHANGES, BUT WHEN the much-loved shell cameo brooch was discarded at the beginning of the 20th century, the craving for pictorial jewelry lingered. From another fashion arena came a craze for jewelry set with ancient coins, available after c.1850 from many archaeological digs, and the combination of coin design and pictorial decoration led to the medal jewel. At first a French innovation, it was later adopted in America for mass production.*

*BOTH THESE BROOCHES ARE FRENCH. THE ENAMEL PROFILE (above), c.1905, depicts "Parisienne" wearing diamond-set jewelry – a technique known as* habilles *– while the 1890 Pre-Raphaelite-inspired portrait of Joan of Arc (below) creates a patriotic jewel.*

Width above *c.*1½in/3.5cm  $C; below *c.*1¼in/3cm  $B

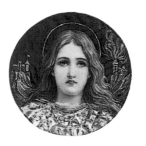

# Medalists

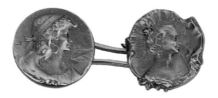

*THE POPULARITY OF MEDAL JEWELS MADE IT
easy to cater for gentlemen with a variety of
cufflinks, cravat pins, and watch fobs, which were
cast or die-struck with fashionable images. Many
of the noted medalists of the day turned their skills
to cutting the original designs, which were
then mechanically reduced in size, a process known
as* tour à reduire, *and reproduced.*

*IN THESE CUFFLINKS, THE IMPACT OF MACHINE PRODUCTION
was softened by varying both the shape and
profile of each of the four plates and incorporating
the work of at least two medalists. Two of the
designs were initialed "L.R." for Louis Rault, and
one "E.V." for Emile Vernier, one of the first
medalists to turn his talents to jewelry in 1887. The
cufflinks were made c.1900.*

*THE INITIALS, AND HENCE THE NAMES OF THESE MAKERS,
can be traced through the comprehensive*
Biographical Dictionary of Medalists *compiled by
L. Forrer and reprinted in Paris in 1904.*

Diameter plates ½in/1.5cm  $C

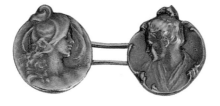

# Japonisme

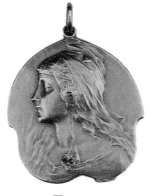 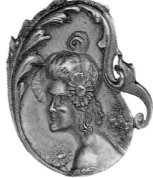

*THROUGHOUT THE SECOND HALF OF THE*
*19th century, Japanese art was a great influence*
*on French designers, who appreciated the economy*
*of line, lively palette, and mixed-metal*
*techniques. Trade was reopened with the East in*
*the late 1850s, and the Japanese display at*
*the International Exhibition in London in 1862*
*made a deep impression.*

*SEVERAL LEADING FRENCH DESIGNERS PRODUCED*
*fashionable jewels in the Oriental manner, while*
*entrepreneurs such as Samuel Bing and Arthur*
*Lasenby Liberty stocked a wide range of textiles,*
*ceramics, metalware, and prints in this style, along*
*with more typical Art Nouveau objects.*

*ORIENTAL-STYLE PIECES SOLD BY BING AND LIBERTY*
*may well have included brooches similar to that*
*on the right, showing a girl with her hair dressed*
*in the Japanese manner, symbolically decorated*
*with chrysanthemums. The pendant on the*
*left depicts the typical idealized portrait of French*
*womanhood. Both were made c.1905.*

Width left *c.*1½in/3.4cm  $A; right *c.*1¼in/3cm  $B

# Pendant & aide mémoire

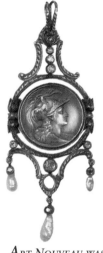
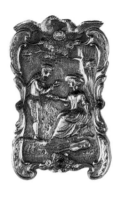

A<span style="font-variant:small-caps">RT</span> N<span style="font-variant:small-caps">OUVEAU WAS AT ITS HEIGHT FROM</span> **1895**
*to 1910. Public appreciation of the style was focused
by Samuel Bing's gallery opening in 1895 and carried
through by the glories of the Paris 1900 Expo,
but it waned as war loomed in Europe. The pieces
above date from either end of the period.*

T<span style="font-variant:small-caps">HE AIDE MÉMOIRE (RIGHT) WAS MADE</span> C.1870.
*Its diamond and ruby mounted gold cover, with
repoussé symbols of love and nature, opens to reveal
four ivory leaves on which one could write in pencil.
The twin doves, glade setting, and scrolling border
point to the forthcoming wave of naturalism.*

T<span style="font-variant:small-caps">HE MEDALLIC PENDANT (LEFT) USES A CENTRAL</span>
*Art Nouveau device, but updates it with
clean ropework lines, contrasting with the natural
shapes of the baroque pearls. It is signed
"R. Bouvet," recorded as an exhibitor at the
Musée Galleria in Paris in 1908.*

**Length left 3½in/9cm   \$B; right c.2½in/6cm   \$B**

# The seasons bracelet

ENAMEL DECORATION OF JEWELRY HAS A LONG
tradition. By the 15th century, it was a recognized
art form in Limoges, France, where painters
specialized in applying translucent enamels over a
dark background, using several layers of shaded gray
and white – grisaille – or soft tints.

BY THE EARLY 1800S, THE SWISS WERE PRODUCING BEAUTIFUL
enamel panels of lake and mountain views on gold
backgrounds, for use in jewelry or objects of virtu,
with the scene painted over a fired neutral matte
background and then glazed. A specialty was to
depict the costumes of the cantons on small plaques,
which were often mounted as bracelets.

THE FRENCH MAKER OF THIS BRACELET, DATING FROM
c.1910, has created a similar piece in painted enamel,
adorning female profiles representing the seasons
with the bounty of nature – spring cherries, summer
grapes, autumn apples, and winter berries – and
joining the panels with garnet-set links.

Length 7in/18cm   $C

# The whiplash line

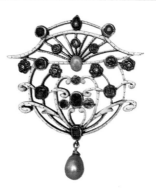

*THE LINE THAT CURLS THROUGH MANY ART*
*Nouveau jewels like a whiplash refined the tendrils*
*of naturalism, embraced the expressive lines of*
*japonisme, and expressed the style's vitality.*
*IT IS FOUND IN BOTH OF THESE BROOCHES MADE C.1900,*
*although they were aimed at two very different*
*markets. The one above, in gold decorated*
*with white enamel and set with diamonds, rubies,*
*sapphires, emeralds, an opal, and a pearl, would*
*have been an ideal gift for a young bride.*
*DIAMOND-ENCRUSTED ART NOUVEAU JEWELS ARE RELATIVELY*
*rare, and the brooch below, composed entirely*
*of diamonds in platinum mounts, would have been*
*made for a bride of much higher social status.*
Width above 2½in/6.5cm  $C; below c.2¼in/5.5cm  $E

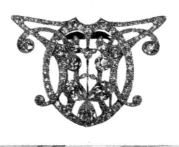

# Archibald Knox pendants

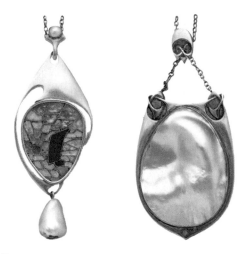

BORN ON THE ISLE OF MAN IN *1864, ARCHIBALD
Knox studied at the Douglas School of Art and then
taught there until 1888. In 1899, Arthur Lasenby
Liberty launched Knox's "Cymric" line of
silverware and jewelry. Knox derived much of his
inspiration from Celtic interlaced designs,
which made his work distinctive, despite Liberty's
insistence on the anonymity of his designers.*

BOTH OF THE PENDANTS ABOVE ARE GOOD EXAMPLES OF THE
Liberty style c.1900. The one on the left is set
with a mosaic of shaped slices of multicolored opal
set in a gold grid, with a pearl-set suspension
loop and a large baroque drop pearl.

Length c.2½in/6cm   $D

THE JEWEL ON THE RIGHT DISPLAYS KNOX'S "TRADEMARK"
of enamel-filled entrelac (interlaced) knots
supporting a large blister pearl – one that forms
partly attached to the shell lining.

Length 3in/7.5cm   $D

# Amethyst necklace

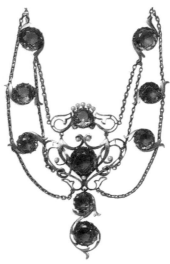

*A* POPULAR STONE FOR BOTH CHURCH AND
*royal regalia, amethyst is the purple variety of*
*quartz. It derives its name from the ancient Greek*
amethustos, *meaning not drunken, for it*
*was said to protect the wearer from the effects*
*of wine and to sharpen the intellect.*

*T*HE PROPERTIES IMPUTED TO THE STONE AND ITS COLOR,
*which in the 19th century was acceptable in*
*the later stages of mourning, made this necklace,*
*dating from c.1900, suitable for almost any*
*occasion. Nevertheless, it was styled in the height of*
*fashion, with whiplash curls and floral scrolls joined*
*by chain swags, the pendant link connections*
*between the various parts insuring that the necklace*
*would lie flat around the wearer's neck.*

*W*ITHOUT RESORTING TO EXPENSIVE GEMS, THIS BOLD,
*attractive piece makes a strong fashion statement.*
Length center section 3¾in/9.5cm   $D

# Worn with feeling

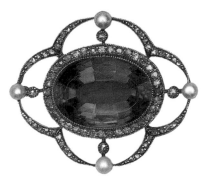

*J*EWELRY SERVES SEVERAL FUNCTIONS APART *from beautifying the wearer. Sometimes, as with a wedding ring, it establishes social status; it can also indicate affiliation to a specific group. Both of these brooches belong to the latter category.*

*T*HE BROOCH BELOW, WITH THE CROWNED DATE 1911 AND *enameled rose and thistle celebrating George V's coronation, proclaims the wearer's patriotism.*

Width 1¼in/3.2cm  $A

*B*UT WHAT OF THE AMETHYST, PERIDOT, PEARL, AND *diamond brooch above? Translating the gems into colors gives purple, white, and green, the colors adopted in 1913 by the suffragette movement in Britain and used to promote the cause. It would have required considerable courage and commitment to wear this bold declaration of support.*

Width *c.*2in/5cm  $C

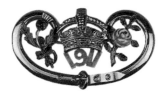

# Liberty buckle

STILL A LEADING FASHION GALLERY, THE famous store of Liberty & Co., on London's Regent Street, is known throughout the world for its distinctive textiles and unusual and exotic decorative items. This remains true to the original concept of Arthur Lasenby Liberty's Oriental Emporium, which he opened in 1875 following experience as manager of the Oriental Warehouse of Falmer & Roger's Great Shawl and Cloak Emporium, also in Regent Street.

THIS BELT BUCKLE IS AN EXCELLENT EXAMPLE OF the "Cymric" line of silver and jewelry which Liberty launched in 1899, in association with Archibald Knox. The organic shapes, with whiplash curls, combined both Celtic and naturalistic influences to form a fluid design enriched by delicate surface texturing.

MADE OF STERLING SILVER, THE BUCKLE WAS HALLMARKED for 1901 in Birmingham, the manufacturing center for small silverware. It was marked "Cymric," and both panels were numbered to make sure that they stayed together from casting to finishing.

Width 3in/7.5cm  $B

# Hatpins

IN A HIGHLY MECHANIZED FACTORY AT HALIFAX
in the north of England, Charles Horner specialized
in mass-produced thimbles and hatpins. Large
hats, fashionable at the end of the 19th century, were
secured by means of long Sheffield steel pins with
decorative terminals of gold, silver, or gilded metal,
often set with quartz gems or paste.

THEMES FOR MANY TERMINALS WERE SUGGESTED BY THE
factory's proximity to Scotland – a ready market for
the golf clubs and the thistle. The latter was portrayed
both realistically in silver and citrine and as a
whiplash line in gold and amethyst. These hatpins,
marked "CH," date from c.1890 to 1910.

AS HATPINS BECAME UNNECESSARY, THE DECORATIVE HEADS
were often mounted as brooches or pendants.

Length terminals c.1–1½in/2.5–3.5cm
Collection of 35 pins $B

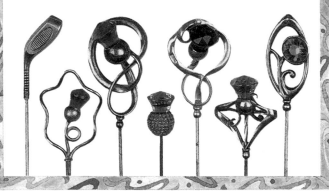

# Collectible pieces

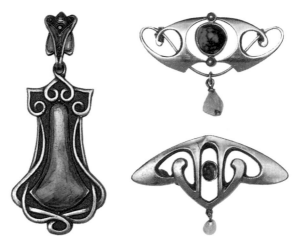

*HIGH-QUALITY INDIVIDUAL DESIGNER-MADE PIECES*
*are of such value that most are bought by*
*museums or wealthy collectors. But many Art*
*Nouveau jewels can still be bought for under $600,*
*and they will probably appreciate in value.*
*IT IS WORTH ATTENDING THE VIEWING PERIOD OF AN*
*auction, when you will be able to handle and*
*examine pieces. Look for a combination of design,*
*quality, and condition; but remember that*
*in this price range, most pieces will be machine*
*made and only finished by hand.*
*THE STRONGLY STYLED SILVER PENDANT ON THE LEFT,*
*with perfect peacock enamel, is inexpensive*
*but good. Below right is a hollow, 9-carat gold*
*stamped brooch, set with a mediocre ruby –*
*pretentious but poor; while above right is a signed*
*Murrle, Bennett piece, at the top of the*
*price range, but worth buying.*
Length pendant *c*.3in/7.3cm   $A; width brooches 1¾in/4.5cm   $A

# Jet-stream brooch

**W**HEN CONSIDERING THE HISTORY OF **A**RT **N**OUVEAU, *it is surprising how far back into the 19th century it is necessary to go to find the first indicators of the coming fashion. Similarly, at the time when Art Nouveau was at its height, other trends were already becoming evident.*

**T**HIS REMARKABLE JET-STREAM BROOCH DATES FROM 1902, *one year before the Wright brothers' first flight started the age of air travel. Although it contains many of the elements of Art Nouveau style, the similarity to airline logo designs almost a century later is quite startling.*

**I**T WAS MADE BY **P**ETER **W**YLIE **D**AVIDSON OF **G**LASGOW, *probably from a design by Frances McNair, one of "The Four" at the Glasgow School of Art. Davidson is known to have executed silver, metalwork, and jewelry for Charles Rennie Mackintosh, Herbert McNair, and Frances McNair; and although the brooch is not signed by the designer, it is closely related in style to Frances's early watercolors.*

Width 5in/13cm  $E

# Glossary

**BAGUETTE** A cut that produces a narrow, rectangular-shaped gem with a subdued brilliance; useful as a supporting stone in complex settings.

**BRILLIANT CUT** Mostly used for diamonds, the 58 facets on this cut produce maximum brilliance by reflecting light internally.

**CABOCHON** A smooth rounded flat-based stone with high polish displaying color or an optical effect such as the sheen of moonstones.

**CAMEO** Usually carved from a stone with layers of color, the subject stands proud of the contrasting background.

**CHAMPLEVÉ** Type of enameling in which the enamel is used to fill areas engraved or cut into the body of the jewel.

**CLOISONNÉ** Enamel used to fill "cells" made from wire and applied to the surface of the jewel.

**ENAMEL** A powder, normally of silica and potash, bound with oil, which produces glass when fired. Metallic oxides are added to achieve the desired color, which appears during firing in the kiln. Various enameling techniques were used in the making of Art Nouveau jewelry.

**GEM CUTTING** Pieces of gem material are usually corroded, damaged, and frosted by the forces of nature and must be cut and polished to reveal their fire, color, or special optical effect. There are several types of cut.

**GOLD** Too soft for direct use, gold is alloyed with other metals in various proportions of gold parts in a thousand. The purity of gold is measured in carats (ct.); 22ct: 916/1,000; 18ct: 750/1,000; 15ct: 625/1,000; 14ct: 585/1,000; 12ct: 500/1,000; and 9ct: 375/1,000, the only alloy to contain less than 50 percent gold.

**GUILLOCHÉ** Transparent enamel applied over a surface decorated with lathe-cut engine-turned patterns which are visible through the enamel.

**INTAGLIO** The subject is carved or engraved into the surface of the stone; when making seals the image must be reversed.

**PAILLONS** Spangles of gold, silver, or other metal set between two layers of translucent fired enamel.

**PAINTED ENAMEL** Enamel applied with a brush as an oil-bound powder; when it is fired, the oil evaporates.

**PIQUÉ ENAMEL** A ground of one color of enamel, often white, decorated with lines of enamel dots in a contrasting color.

**PLIQUE-À-JOUR** Spaces are filled with transparent enamel without any backing, creating a stained-glass window effect.

**ROSE CUT** An Indian cut, originally used for important diamonds, but later restricted to small, thin flat-backed stones with domed triangular-faceted tops.

# Index

---

# Acknowledgments

All pictures courtesy of Christie's South Kensington except for the following:
David Churchill/Arcaid: 6. Christie's Images: 3t & c; 8–11; 14–15; 19–20; 25; 28–29; 36–40; 46–47; 51–57; 59; 61–63; 66; 67r; 71–72; 74; 77; 80. Christie's New York: 13; 35; 48t.
Illustrators: **Lorraine Harrison** (borders), **Debbie Hinks** (endpapers).